VETERAN GUILT

in Pictures & Words

by Clyde R. Horn

Veteran Guilt in Pictures & Words

© 2014 Clyde R. Horn, Veteran/Photographer

ISBN: 978-1-61170-170-8

Photographs by Clyde R. Horn

All rights reserved. No part of this publication may be reproduced, stored in a retrieval system or transmitted in any form or by any means, electronic, mechanical, photocopies, recording or otherwise, without the prior written consent of the author.

Printed in the USA and UK on acid-free paper.

Robertson Publishing™
www.RobertsonPublishing.com

For additional copies of *Veteran Guilt in Pictures & Words* or *PTSD in Pictures & Words* go to:

 amazon.com
 barnesandnoble.com
 www.rp-author.com/horn

**Dedicated to my wife, Thu and son, Nick,
for their unlimited Love and Constant Support.**

Throughout the narratives I emphasize how important having support systems are in recovery from Trauma/Guilt/PTSD.

My family has gotten me through tough times. I am forever grateful.

Clyde

I'm Clyde R. Horn, a combat soldier who was wounded in action, December 6, 1967, in the Vietnam War. I served in the 199th Light Infantry Brigade, Company E. I am a 100% disabled veteran who has heart disease, PTSD (Post Traumatic Stress Disorder) as well as other health related issues related to my experience and exposure to Agent Orange (a toxin used in Vietnam).

I have personally experienced guilt feelings due to my combat experience. I have done a significant amount of work towards my recovery including writing, photography as well as art therapy to help bring healing back into my life.

I shot all the photographs and the essays in this book are my original thoughts and words. All the photography was done mainly in the Bay Area of Northern California. The "Arenal Volcano" photograph was taken in Costa Rica and "Infrastructure" was taken in Las Vegas, Nevada.

I intentionally avoid technical terms using my photography and words to convey my personal understanding to the disturbing and sometime difficult discussion of veteran Guilt. This is a topic that has been avoided by professionals and veterans of previous wars due to the difficulty of addressing the traumatic impact it has had upon the generations of soldiers.

My hope is that this book will be a beginning conversation that will lead to healing.

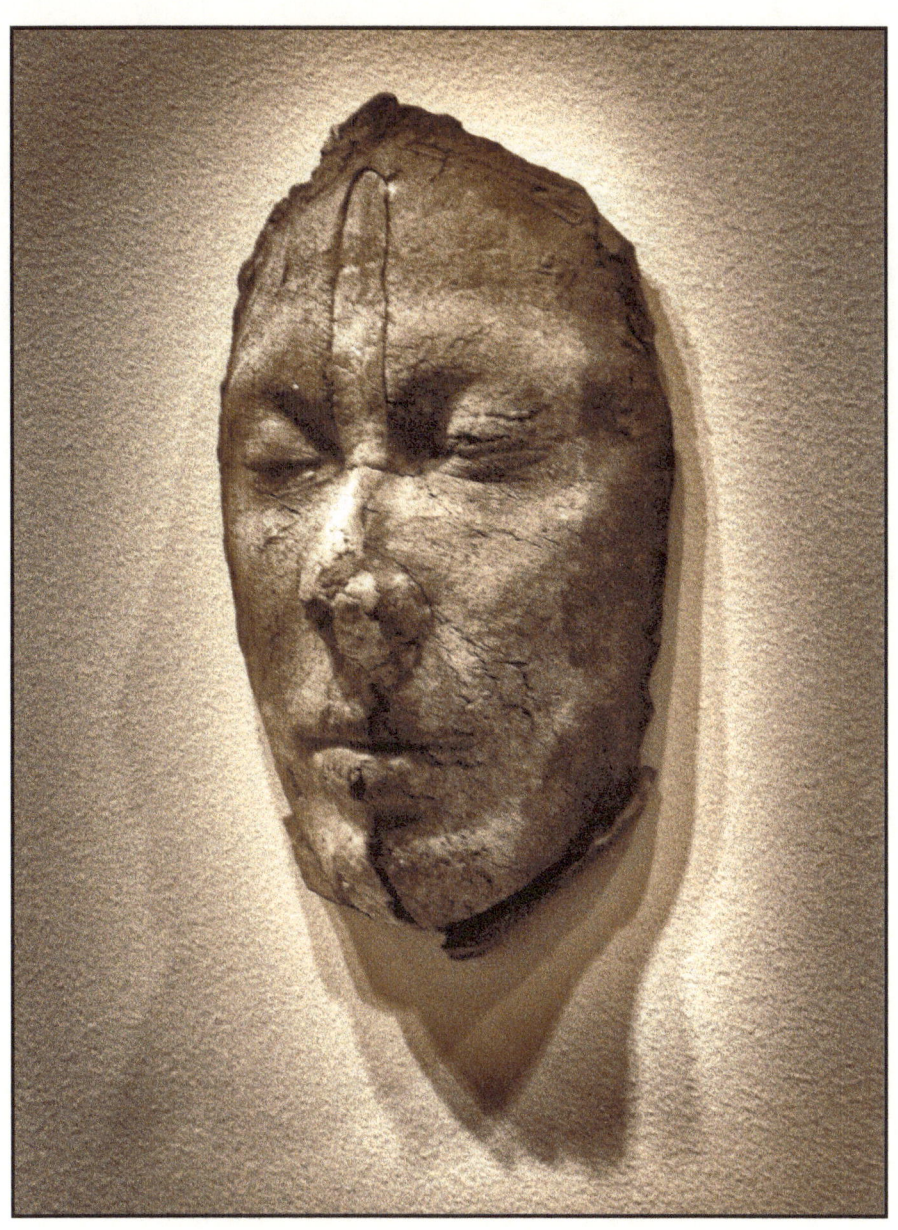

MASK OF GUILT

You went to war or you served your Country during war time. You had all the hopes and dreams that most young people have. You came back different. You are changed and you know it but have no clue how to express, communicate or understand what happened. You were traumatized. You were wounded, emotionally, spiritually, and maybe even physically. You are called a "Hero" having no clue what that means.

You ARE RACKED WITH GUILT! How is that possible???

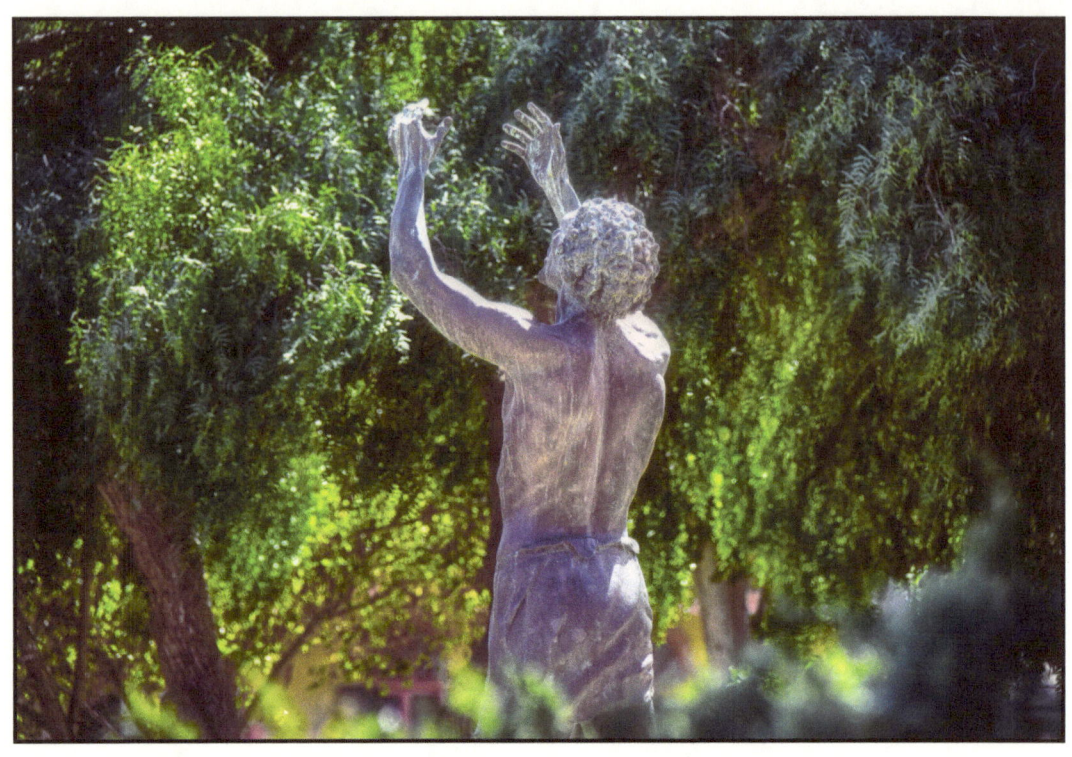

UNFORGIVABLE

What happens if you feel the people who can forgive you are dead? What if you killed a child in war or saw others do things that violated your moral code and you said or did nothing?

You become a "nothing." You are not worthy of love. You devalue yourself raising your arms to the heavens in the deepest of agony. You are alone. Deadly alone.

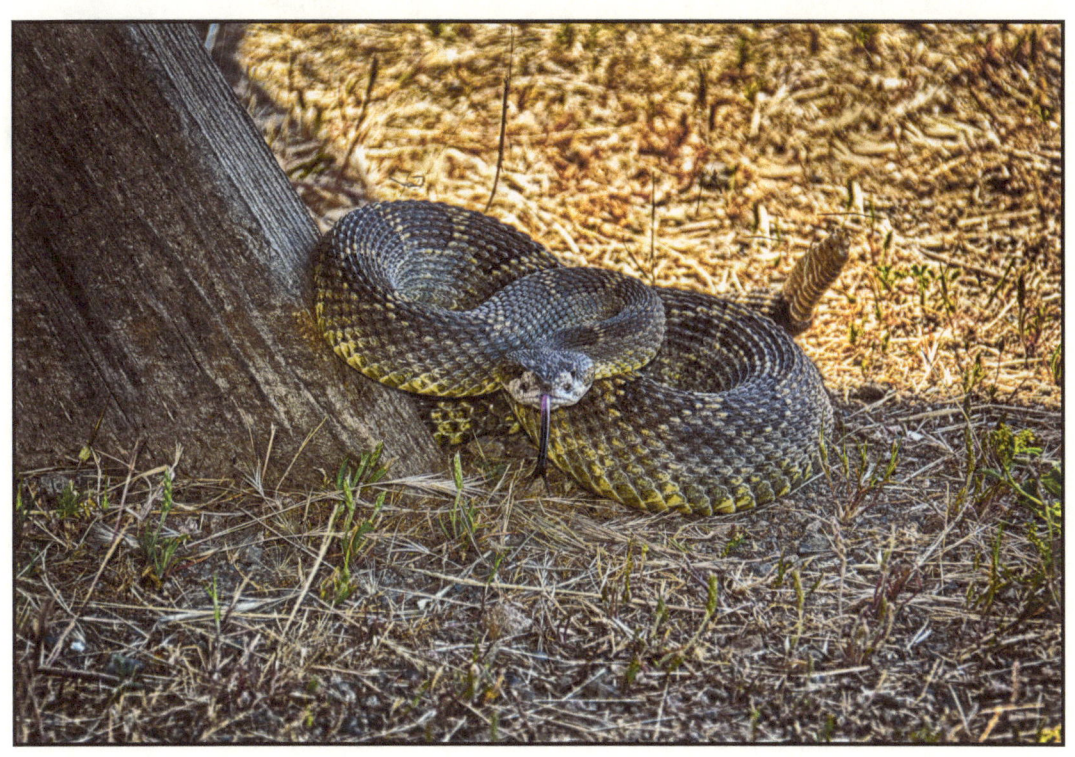

LETHAL

Killing is not a normal act. I'm told war makes killing "different" from other types of killing. Maybe it does, but I suffer because of it. My mind won't let it go.

Some "experts" call this a moral injury defined as wounds from having done something or failed to stop something that violates the person's moral code. This is also called "inner conflict" meaning something that tortures the conscience. A soldier might experience deep shame, guilt and even rage.

It's often not talked about even in PTSD (Post Traumatic Stress Disorder) treatment. Many soldiers can't even define it or put words to it. It is a deadly feeling that can lead to suicidal ideation or self-destructive behavior.

WHY IS THIS PICTURE FUZZY?

Moral injury occurs because you have violated your value system in a significant way. Your morality may come from your family value system, your religion or spiritual beliefs, your personal insight and/or wisdom or a host of other possibilities. However, your values or moral beliefs are part of your deepest sense of self. When you violate them you have committed a self-destructive act. This violation goes to the core of who you are. Finding a way back to patch the hole in your heart is a tough battle.

You're told by society, the military or by cultural acceptance that fighting in war is a heroic act. Once you participate you may find you become morally bankrupt. What you were told and what you experienced violates your deepest beliefs.

Why many things might seem simple—getting to the depth and scope of violating your personal value system is quite the fuzzy picture.

You may need to take a spiritual journey whatever that means to your sense of morality. If you believe this takes penance then you may need to do penance. If you believe this means redefining your belief system then that is what it will take for you to find forgiveness.

The picture only becomes clear when you are clear according to your moral code on how to redefine or come to grips with your violation and through the means of understanding your moral code what that code requires to get beyond the guilt, shame and humiliation of the violation.

Universally major religions believe in forgiveness rather than life condemnation. It's the extreme end of the religious and spiritual spectrum that limit the scope of coming back from serious mistakes up to and including murder and mayhem.

It is easier to forgive others than yourself. Veterans tend to be hard on them-selves. Yet we are just as vulnerable as any other human. Humans make mistakes and sometimes very bad decisions. You are forgivable just as I am.

You don't have to take this journey alone because those who believe in you are waiting to be asked to help you in your journey. The more support you have the easier the path to recovery.

Go for it!

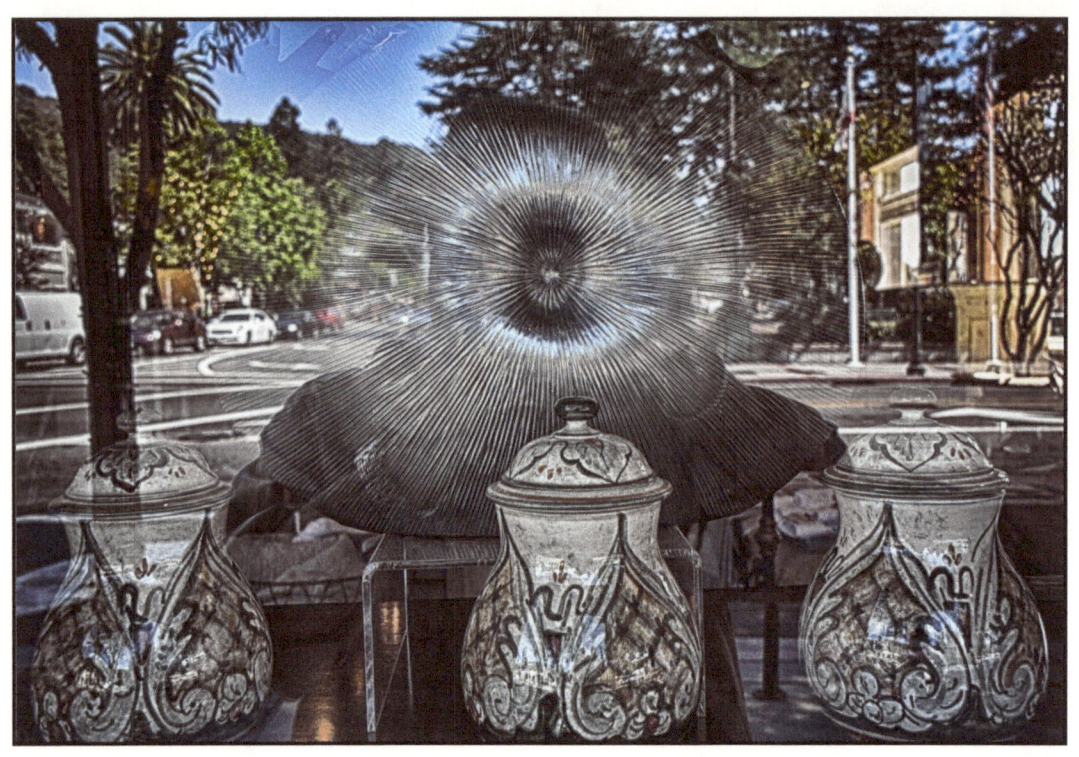

I AM THE ONE

I am The One who lived…

I am The One who held my dying buddy looking into his eyes that never closed…

I am The One who dreams of his death…

I am The One who wonders if I could have done anything differently to save him…

I am The One who carries the shame and guilt of it all…

I am The One who doesn't hear the words "it wasn't your fault."

Yes, I Am The one.

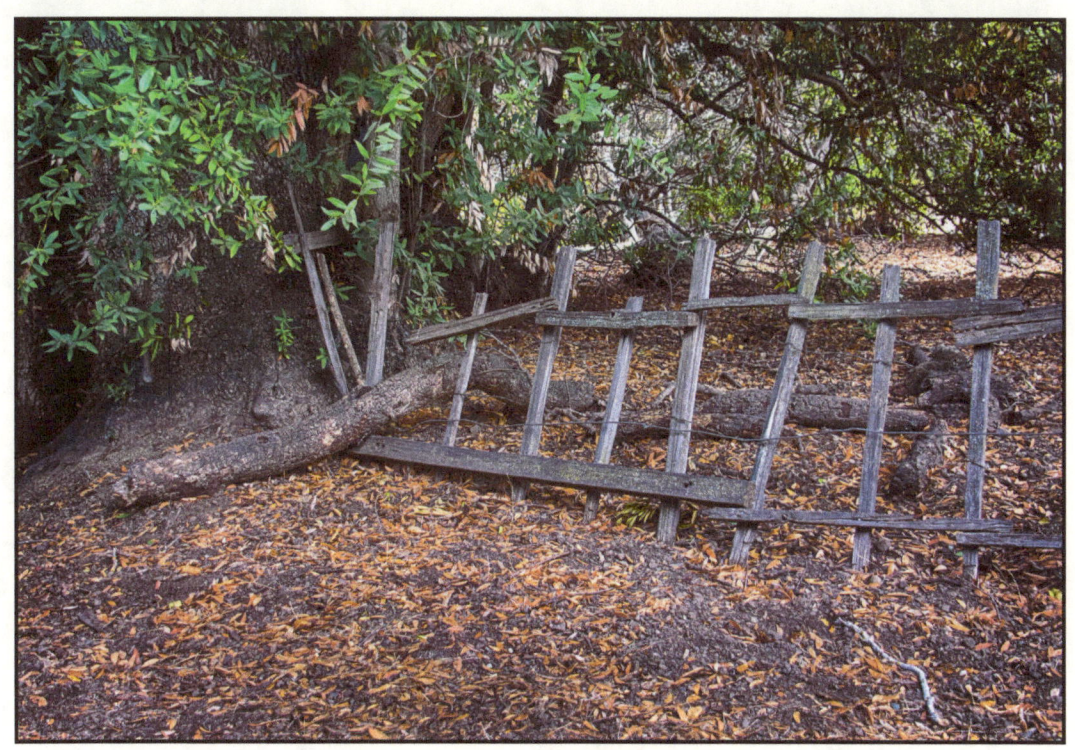

THE FALL

We build defenses to protect us from pain. It is only natural. Then something unusual happens outside the normal curve of life. Something breaks through the defenses and wounds us. It seems to fall from the sky, fracturing our soul.

We are close to being mortally wounded…hurt beyond words, hurt beyond explanation.

This is TRAUMA. It takes away the pleasure of doing life.

Trauma takes away the ability to be with others.

Trauma takes away trust.

Trauma, untreated, leads to isolation.

Trauma creates shame—a horrific hate of yourself only getting worse as the guilt permeates the soul.

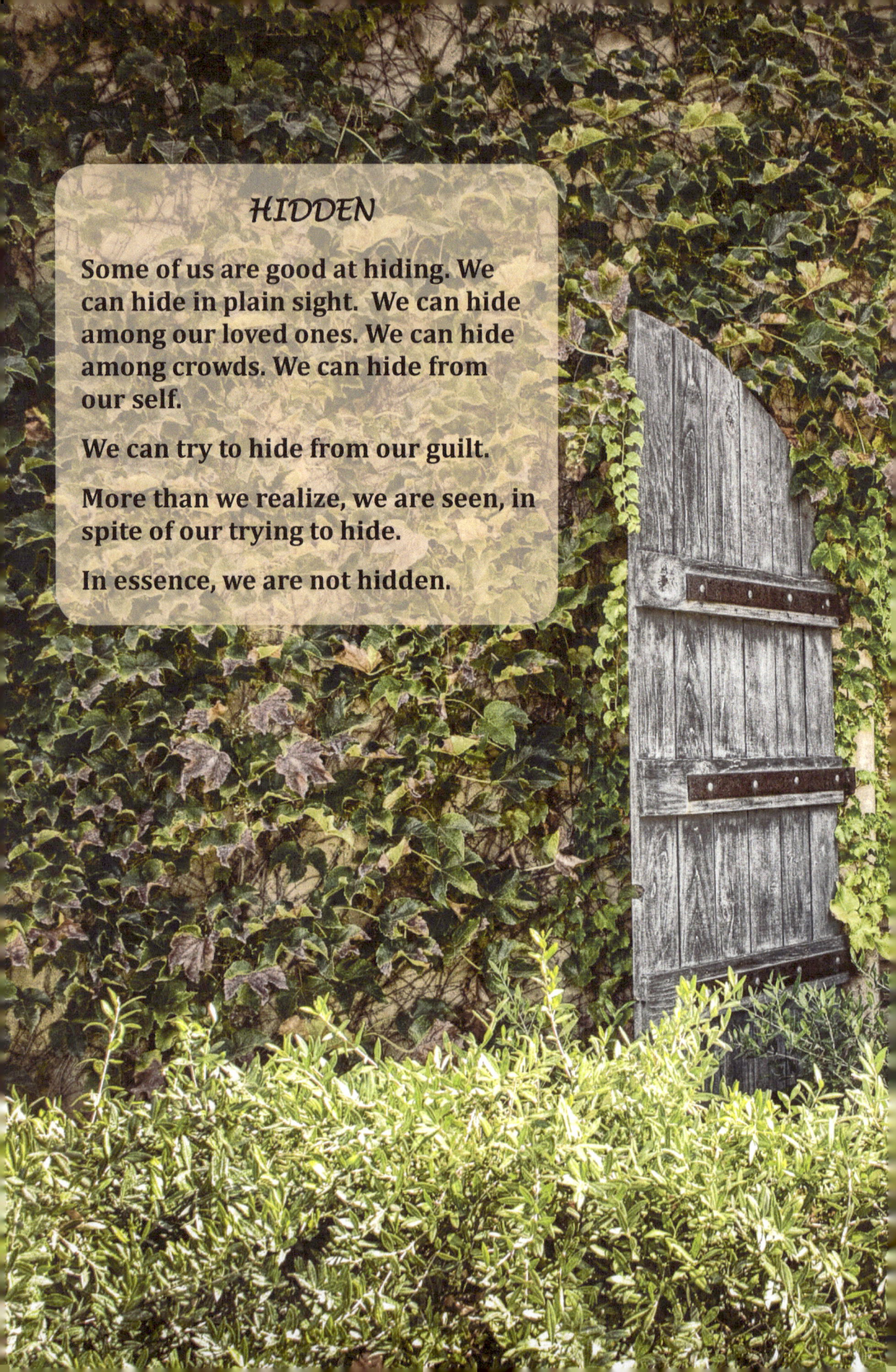

HIDDEN

Some of us are good at hiding. We can hide in plain sight. We can hide among our loved ones. We can hide among crowds. We can hide from our self.

We can try to hide from our guilt.

More than we realize, we are seen, in spite of our trying to hide.

In essence, we are not hidden.

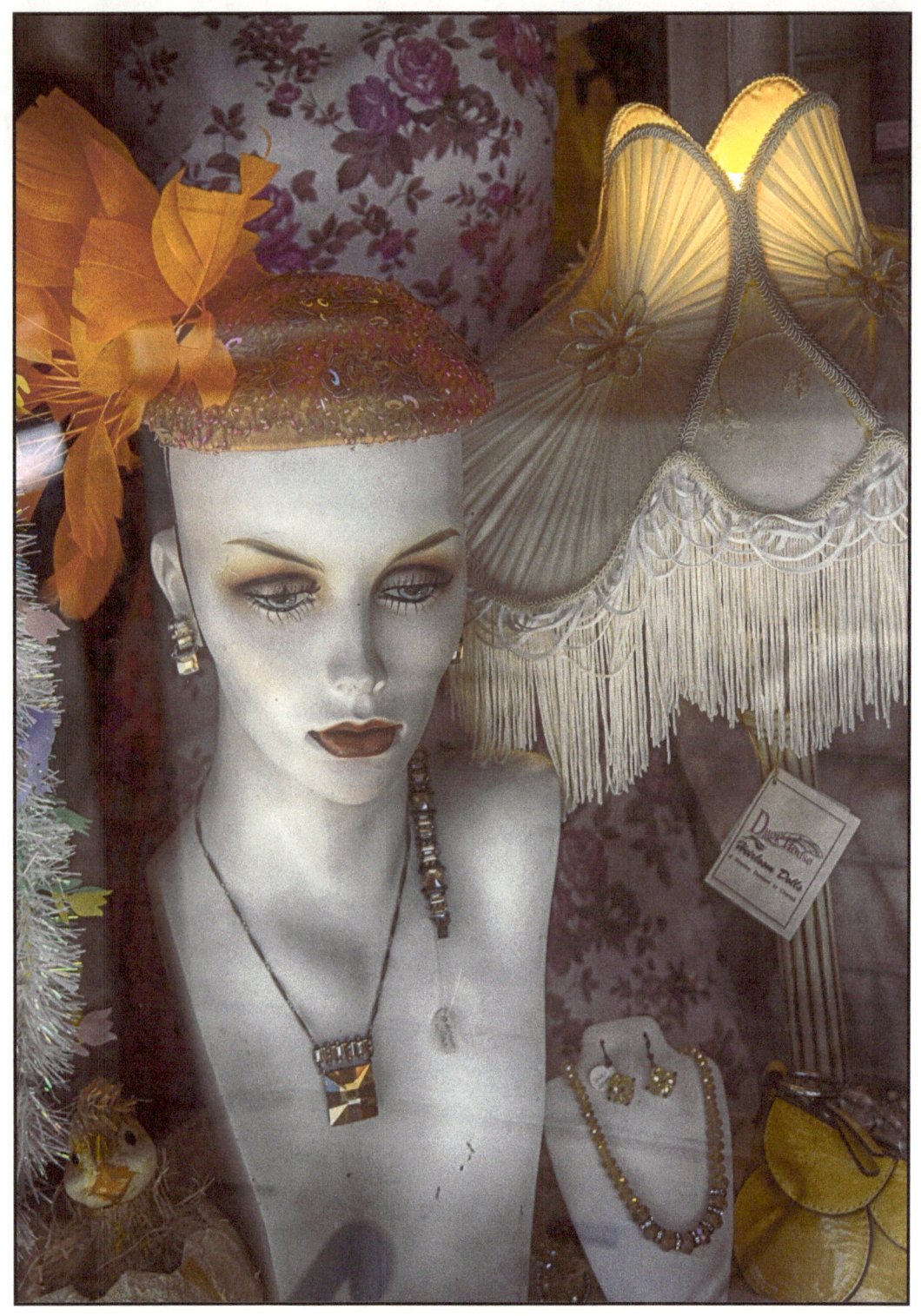

INTIMACY

Guilt disrupts intimacy. No matter how much you love your family they might as well be mannequins because your love cannot penetrate until you reduce your internal pain.

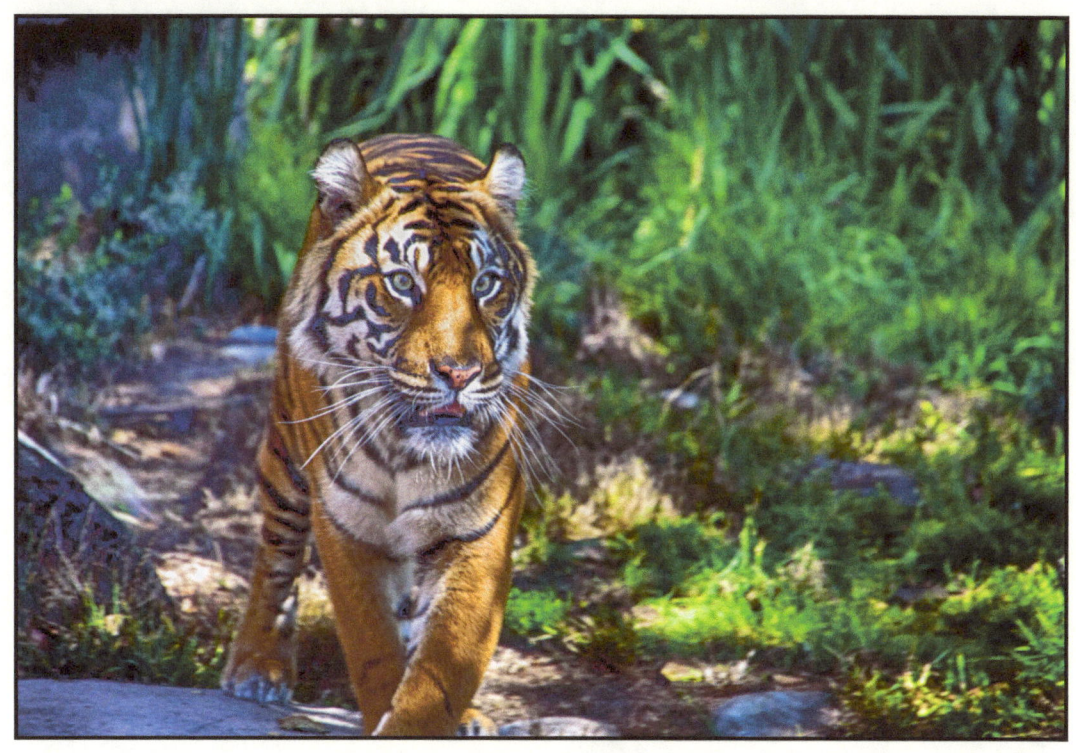

WHEN GUILT GRABS YOU

When guilt grabs you it is tenacious! Guilt doesn't want to let go because it has a super glue effect. Guilt uses your weaknesses against you. Veteran guilt usually comes from deep seeded trauma. Trauma creates false guilt and amplifies valid guilt.

Guilt is distorted under the stress of trauma. Maybe you've done things that shame you or you were a victim yet continue to feel you caused or contributed to a "unforgiveable" incident. The process of growth and knowledge is learning from our mistakes instead of repeating them or condemning ourselves.

Learning from the errors of life is what it means to be a human. This is the way we learn. All humans do or say things they regret. All humans wish they could erase bad or even evil things they might have done.

In other words, you're not human unless you've made mistakes. When we stumble and get up learning from our errors we have created pathways to forgiveness.

Has guilt grabbed you? Learn from it and it will leave.

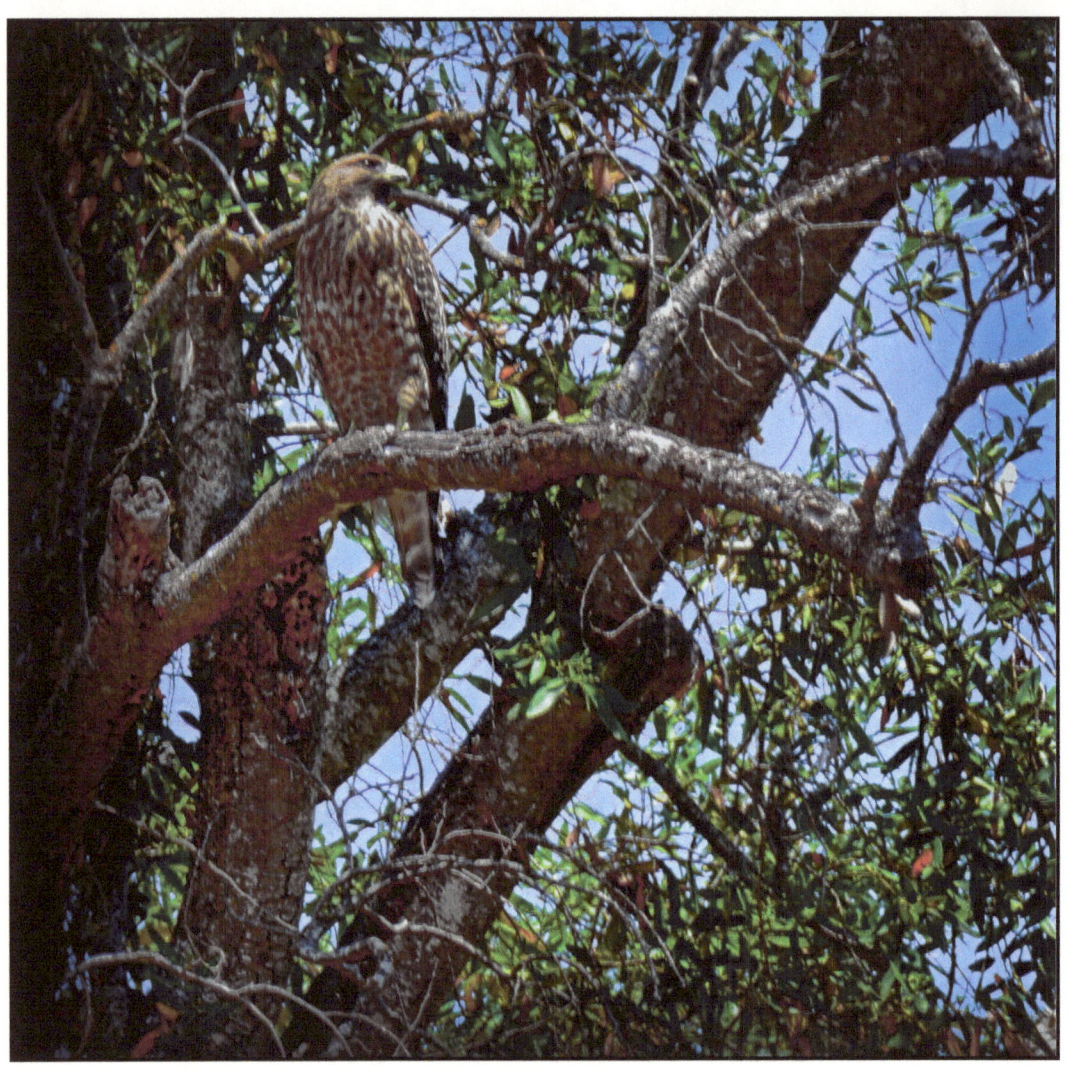

HEALING

Desperation leads to poor decision-making. Part of the healing process is confronting and understanding your guilt feelings. This means you confront the distortions and deletions that confuse your life. This confrontation will lead you to a more sensible way of looking at the whole picture rather than just one aspect. This is where therapy can help.

Therapy can be your own self-exploration, aid by supports like peers, family, counselors or physicians.

Therapy can include diet, self-insight, self-management, exercise and eventually engagement with the community.

INFRASTRUCTURE

Some soldiers feel guilty because they didn't serve in wartime or if they did they were in a "safe place". Serving your Country in a safe zone in peace or war is still stepping "up to the plate" providing the infrastructure that maintains the continuity of freedom. Maybe you don't get medals or recognition but you are part of the foundation that supports the whole. You have my gratitude.

CONSEQUENCES OF GUILT

Guilt is like out-of-control anger. It must have management. It's not rational. Guilt distorts reality only getting worse if not treated. No matter how much you feel you deserve the consequences—capital punishment is too severe a penalty.

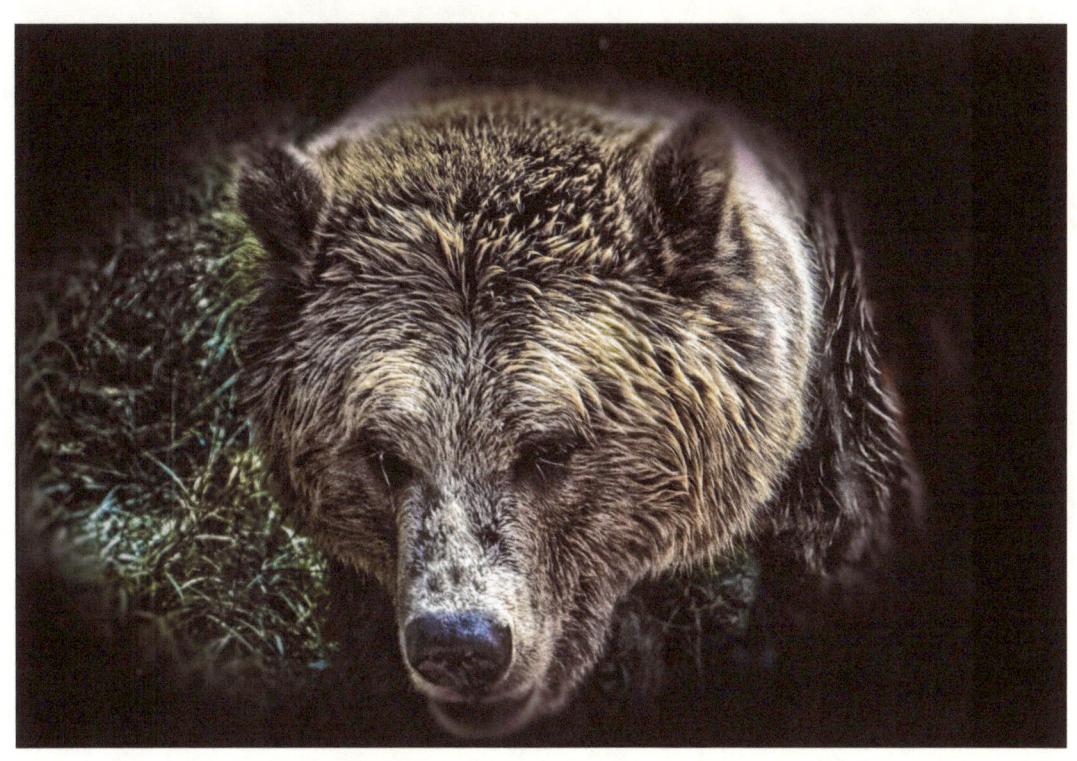

GRIZZLY

Do you have a Grizzly in your face? Are you about to be torn limb to limb? Do you fear for your life or care less? Are you feeling powerless to control the Grizzly force?

It's ironic because the Grizzly is your Guilt. The Grizzly is yours to nurture or displace…

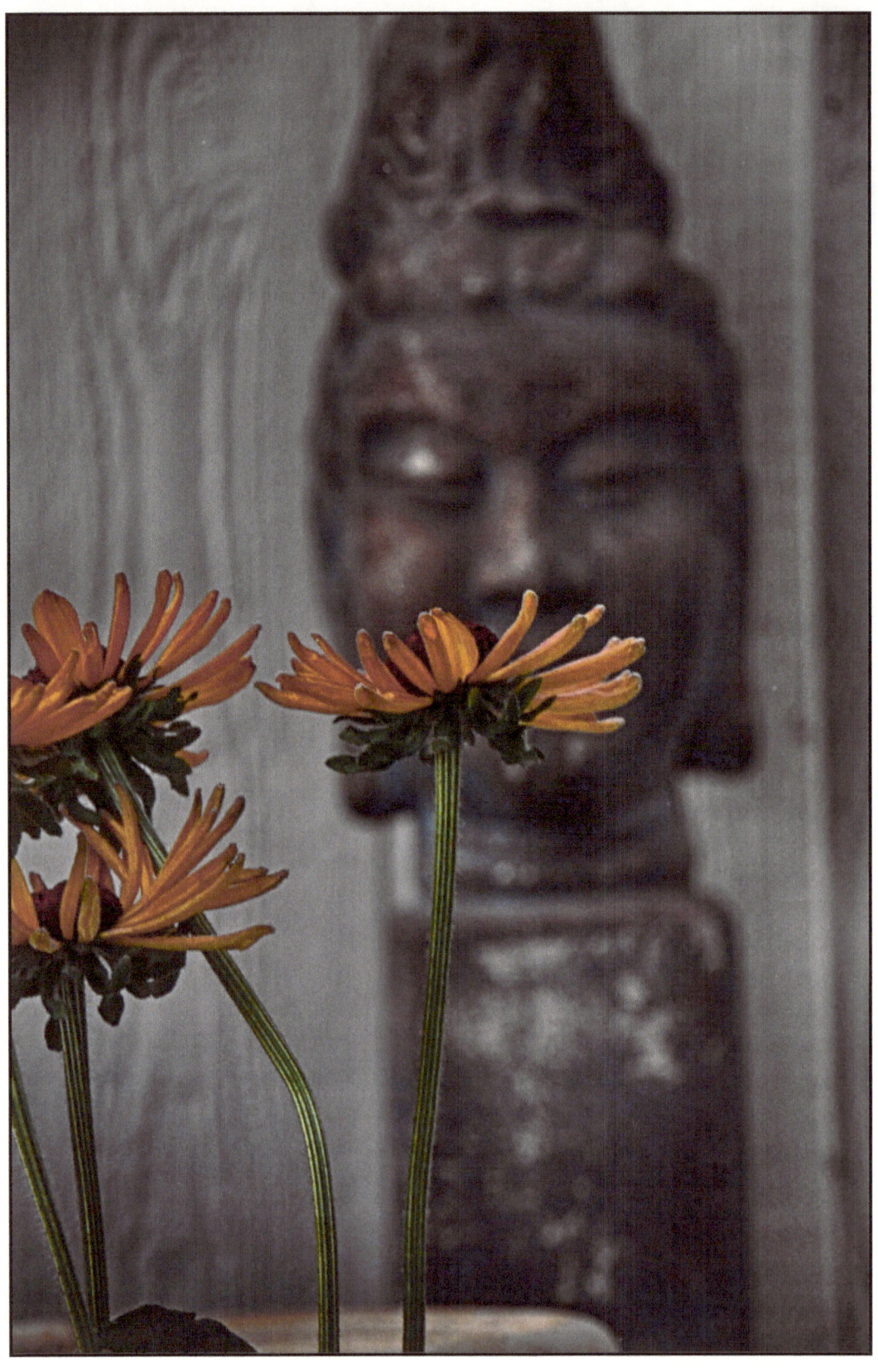

HOPE WINS

IT'S EASY TO BECOME HOPELESS WHEN YOU'VE EXPERIENCED SIGNIFICANT GUILT FEELINGS. GUILT CAN TRIGGER OTHER MOOD PATHS SUCH AS DEPRESSION AS WELL AS POST TRAUMATIC STRESS DISORDER.

Depression feeds on itself taking the guilty to places that attempt to captivate with the message—"Life is not worth living."

Depression, anxiety, phobia's and addictions all tell lies but your body will believe if you don't or can't reach deep to your internal strength or power.

Rather than debate why or why not life has value I suggest you consider an approach that works for me. It is simply this: GIVE BACK. Give freely out of your pain to other veterans or groups that need help.

Giving is an elixir that loosens the grip of guilt—bringing you to a more hopeful position in life.

When Hopelessness encounters hope—HOPE WINS. It's true. Freely giving time to help others in need cleanses the soul by making contributions to healing the wounded as well as your own wounded self.

PONDERING

I want to do more than survive. I want to turn my pain into an avenue of action that benefits others. There is no other way for me to advocate for healing than to be actively involved in doing the work I need to do.

What I've found for me is I need to engage areas in me that respond to a positive process. For me, I must be out in nature. I must give back to the process that has given to me.

Photography, writing books, hosting a weekly veteran's breakfast, participating in veteran activities, membership in The American Legion, The Military Order of the Purple Heart, the Kiwanis International and a Board Member of the Los Gatos Memorial Foundation keeps me busy. This not only helps me move forward, but it also contributes to the ongoing process of the community. I find this works for me.

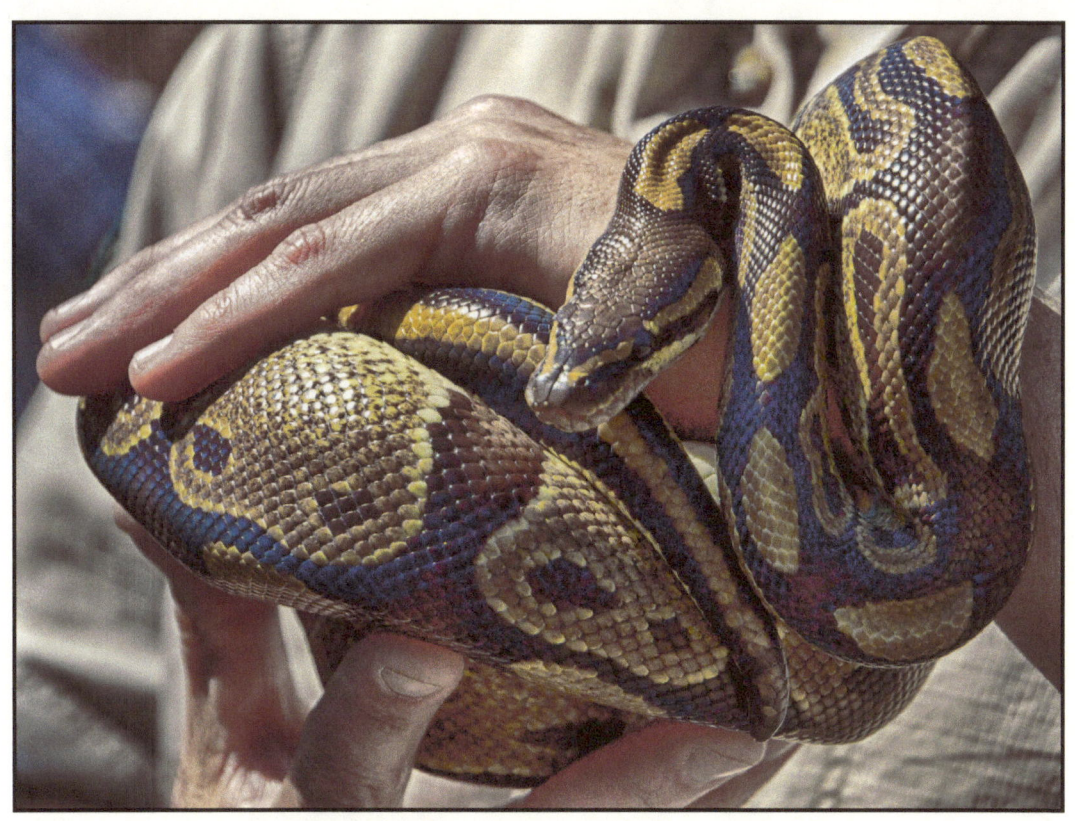

HANDLING THE SNAKE IN YOU

Snakes have represented a duality of good & evil throughout the beginning of time.

You might think life decisions, making choices under pressure, being able to access wisdom or living a "good life" is simple because that is the message of media. It's a lie.

We must learn through our mistakes to make better choices. In other words, we all have snakes in us that need to be tamed. If we've been bit in the midst of our learning we receive a venomous curse. The curse does not go away until we do a tremendous amount of learning — how to handle the snake that is a duality of whom we are.

Handling the serpent is our greater calling because it is one of the major tasks of being human—accepting our faults, forgiving our mistakes so we become better rather than bitter.

Handling the serpent—work, work, and more work…the process of what it takes to wrap the snake around our hand and pet it.

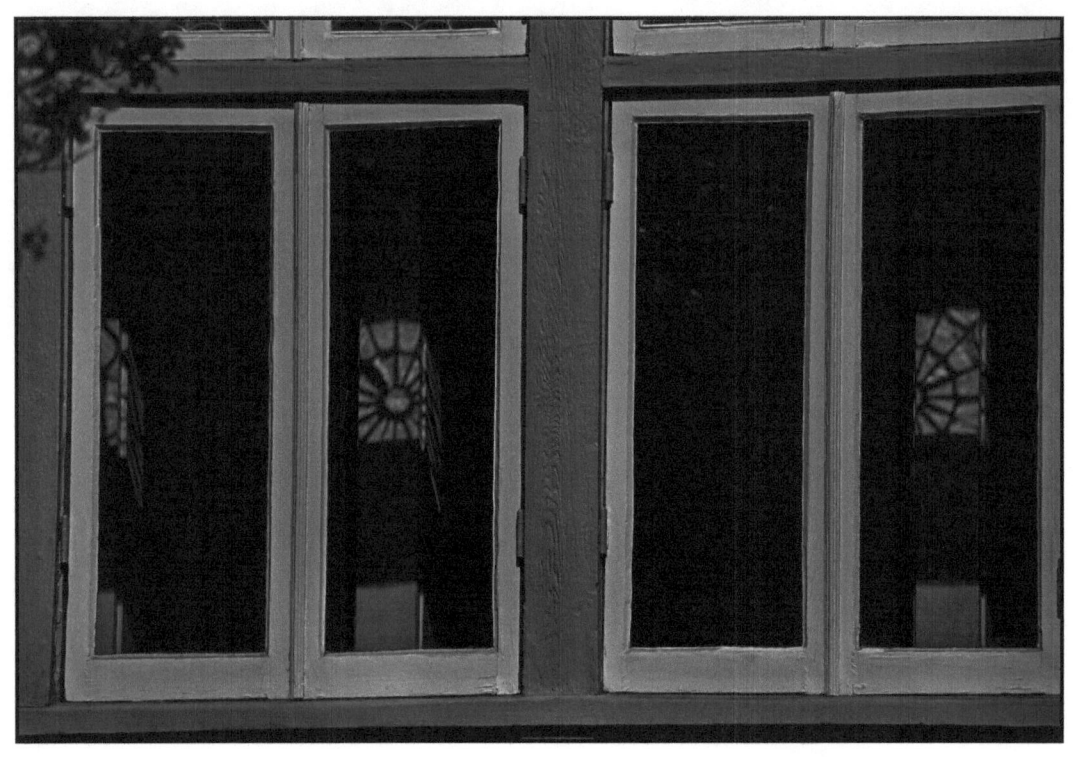

SHADOWS OF SPIDER WEBS

Windows of webs—ready to trap you, ready to
suck your life blood—Beware of the traps Guilt sets
as you struggle to free yourself.

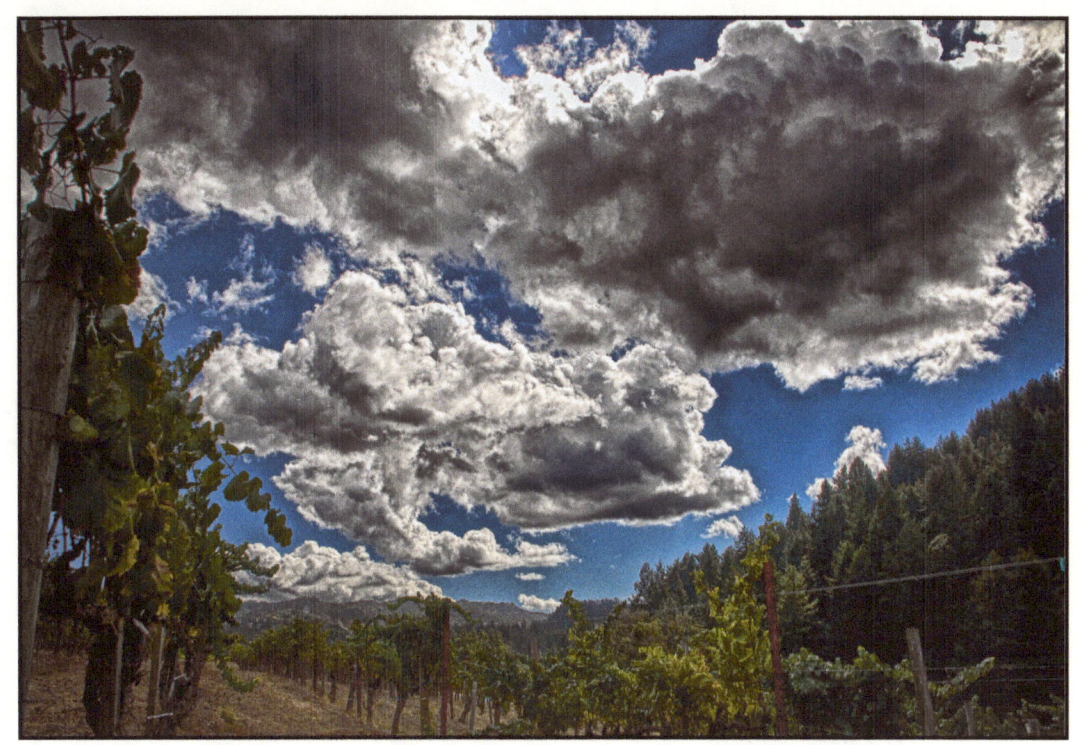

CLOUDS

Clouds close in around us. Even when we make progress we can feel the sun declining. We can taste bitterness. We can see many attempts to get better fail. We can see lack of trust in the eyes of those around us. We find our temper flaring when we know we should not have over reacted. Here we are trying to lessen guilt but our guilt feelings increase.

Clouds can block the sun. They can bring heaviness and change the temperature in our heart. The can come into our lives swiftly and without warning. They can make things worse. Yet--

Clouds actually serve a purpose in nature. They dance and play with the sun. They bring rain to help enhance growth. They have an artistic beauty if you look close. They are not as ominous as they appear. They are part of how the world works.

Let the clouds in your life lead you to a newer perspective-- you're trying, not giving up, continually working even when you slip. There is a beauty to this movement. This beauty is your spectacular cloud formation.

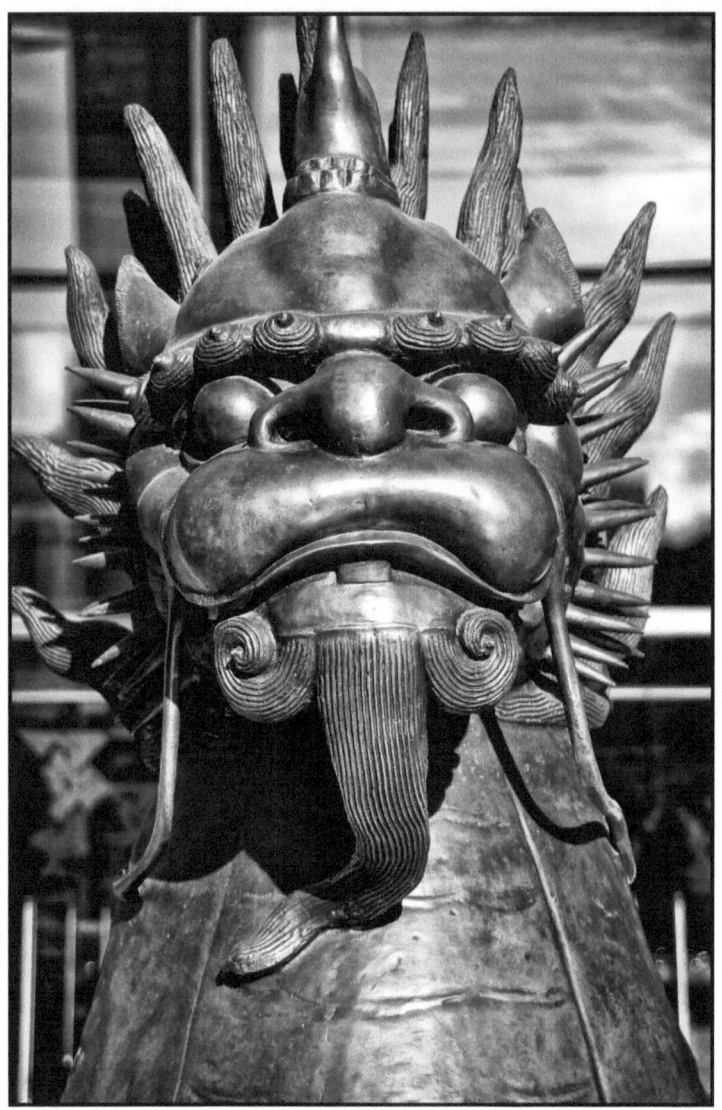

DEMONS OF WAR

A "kid" is given training, a gun and then sent to war.

It may take years or months but the demons of war penetrate the defenses and the "kid" is torn to pieces.

ANGER: sometimes rage blows the top off creating fear for all who make contact.

ANXIETY: a pervasive mood numbing fear paralysis the senses disabling all functions.

MOOD CHANGE: happy to sad, cycling euphoria to deep depression, suicidal thoughts, homicidal ideation, forcing one into deep darkness.

NIGHTMARES: even night terrors invade the dark creating no rest and peace disturbing sleep cycles pushing exhaustion daily.

HYPERVIGILANCE: "over the top" reactions to loud noises, movement, claustrophobic feelings in group settings with paranoia reactions of danger constantly.

ADDICTIONS: the triggering of tendencies to addictive behaviors, including gambling, financial irresponsibility, over engagement in hobbies or play, alcohol, substances or anything to numb feelings.

MEDICAL CRISIS: over-exposure in war to toxins, wounds, psychological stress, or disabilities.

GUILT: surviving when others died, moral turmoil over war engagement, forgetting names of fellow warriors who died, poor ability to concentrate, lack of focus, attention problems, lack of follow-through and motivation.

>The demons of war do their dirty deed indeed.
>The "little kid" is a mess.

This dismal picture is not the whole story. In spite of the hopelessness and mess there are ways out of this morass—Recovery and healing can occur.

1. Begin treatment with Crisis Management before moving to long-term treatments since stopping the pain is the first goal of therapy.
2. Engage the veteran in joining with other veteran's in treatment is one of the best therapies known to help recovery.
3. Educate the family support system to empower them in understanding the dynamics of what to expect of a returning war veteran to promote healing for the veteran and family.
4. Enroll the veteran into the VA system of care to help the veteran receive the medical and financial support he/she deserves.
5. Insight into realizing recovery takes years along with regressive episodes occurring along the treatment path.
6. Help the veteran understand the moral pathway of his/her value structure to address guilt and forgiveness.
7. Evaluate creative ways of addressing deep- seated issues along with the traditional therapies.
8. Do not minimize any health issue that may be related to a service connected- disability by having it evaluated.
9. Embrace all the opportunities for advocacy to secure the avenues available to get the services you deserve.
10. Participate in "giving back" in ways that enable healing.

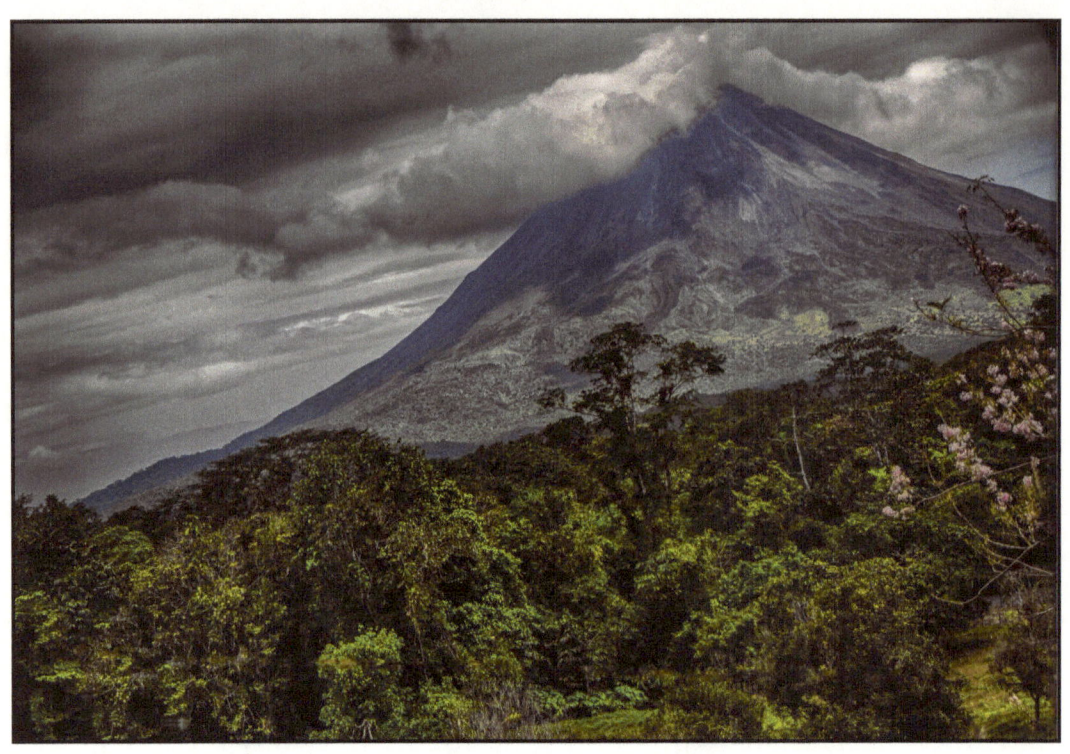

VOLCANO—THE END OR BEGINNING

The energy it takes to hate—whether it is your self or someone else is tremendous. To hold that hate for decades can only cripple a person.

Guilt is not always a bad emotion. But our emotions should lead us to a better place not a prison, not a life sentence of dismay, not a lifelong curse.

Emotions are like the power of a volcano—ready to erupt based on the buildup of internal forces. Emotions, by themselves, have no intellect, they just react to the pressures.

The emotion of guilt means you are human and you have a conscience. The power of guilt can be overwhelming so it needs something to give it balance or stability. That something is your brain, your cognition. What will it take to forgive your self, to come back to life, to live a better quality of life?

Emotions have power and that power drives you. Cognition gives guidance to the emotions providing structure as well as balance.

Don't blow your top destroying all you love by hating yourself. Let out some of the steam by building supports, asking as well as receiving help, doing the work, and getting better.

My wishes to all fellow veterans is you paid the price of serving your country now let your country serve you.

SGT. Clyde R. Horn

199th Light Infantry Brigade, Company E

Vietnam 1967-68

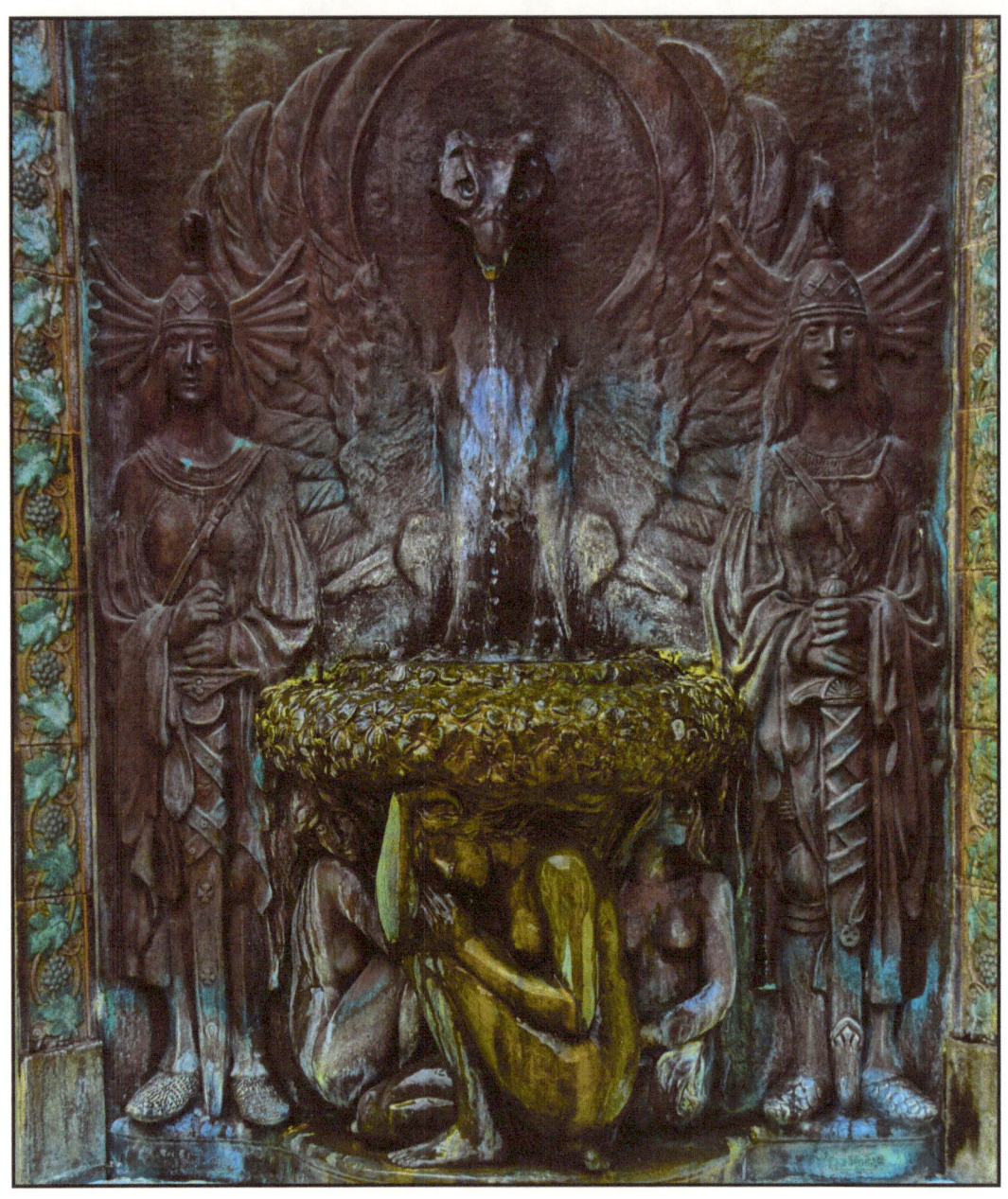

MYSTIC FOUNTAIN

A heavy weight on your shoulders stuck under the table of confusion—GUILT—spreading distortion—just like a mystic fountain.

VETERANS RESOURCES

WEB SITES

 VA Home Page......................www.va.gov

 VA Forms...............................www.vagov/vaforms

 VA Facilities..........................www.va.gov/directory/guide/home.asp

 Returning Veterans............www.seamlesstransition.va.gov

 General newslettermilitary.com

PHONE NUMBERS

 VA Benefits............................1-800-827-1000

 Education...............................1-888-442-4551

 Health Care............................1-800-697-6947

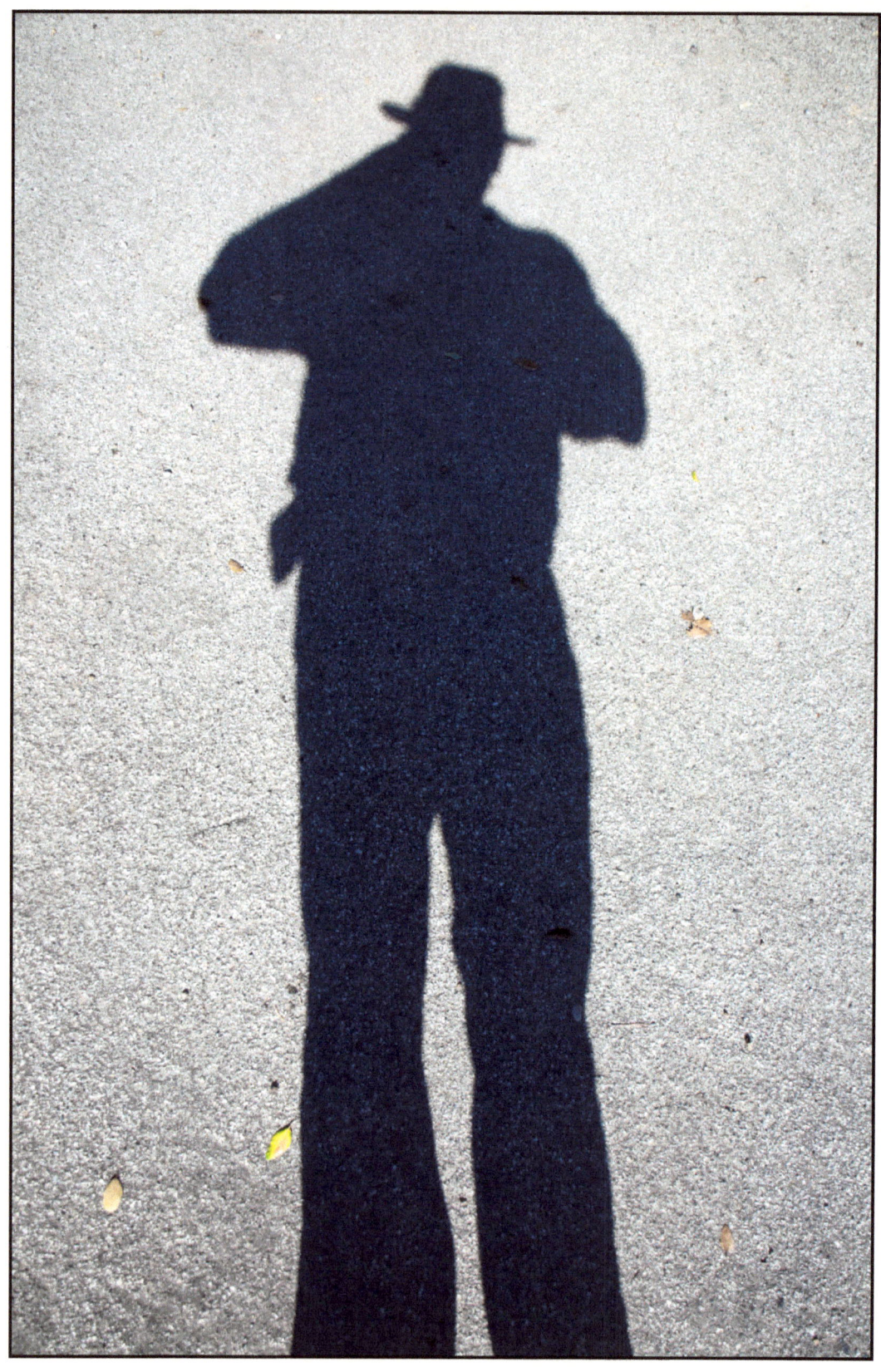

MORE ABOUT THE AUTHOR

Clyde R. Horn is a retired licensed psychotherapist and combat veteran of the Vietnam War (1967-68) He is the recipient of the Combat Infantry Badge, Purple Heart and Army Commendation Medal. He was in Nam during the TET offensive.

Clyde is an author, photographer and veteran right activist. His previous book PTSD in Pictures & Words is available at amazon.com, b&n.com and www.rp-author.com/horn.

Clyde posts a photograph daily on his Facebook page facebook.com/drhorn. Check out his photography.

Clyde will respond to veteran questions through email at drclydehorn@yahoo.com.

www.ingramcontent.com/pod-product-compliance
Lightning Source LLC
Chambersburg PA
CBHW050943200526
45172CB00020B/908